Cameraderie:
A RELATIONAL INTERPRETATION OF PHOTOGRAPHIC HISTORY

PHOTOGRAPHS FROM THE
NEW ORLEANS MUSEUM OF ART

BY STEVEN MAKLANSKY

2000 copies of this catalog were published
in conjunction with the exhibition, *Cameraderie: Photographs
from the New Orleans Museum of Art,* organized by the
New Orleans Museum of Art.

Library of Congress Catalog Card Number: 97-66184
ISBN 0-89494-056-2

Compiled by Steven Maklansky,
Curator of Photographs, New Orleans Museum of Art
Designed by Bridget McDowell, New Orleans Museum of Art
Printing by Hauser Printing Company, Inc., Harahan, Louisiana

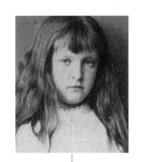

Contents

ameraderie:

Photography has no formalized hierarchy of accomplishment, no minor league, no corporate ladder. Photographers often work as visual free agents, selling their images or their services to clients as varied as newlyweds and newspapers. Stranded in the flux of ideas, images, and commerce, photographers have often sought each other's company, solace, and advice. They have fraternized over new technologies, congregated to discuss new methodologies, studied together at certain universities, and exhibited their work at many of the same galleries.

The modern term for such activity is "networking." This practice of grooming personal contacts and professional relationships with one's colleagues is important business for any careerist, no matter what the avocation. In the field of photography, knowing the right people has proven to be a substantial asset to many practitioners since the invention of the medium in 1839.

For artists who are prone or susceptible to new sources of inspiration, networking can create meaningful repercussions as to the content or character of their own work. For example, what would have happened to Brassai if his friend André Kertész had not convinced him to try his hand at photography? And if Berenice Abbott had not crossed paths with Eugène Atget and his photographs of Paris, would she have ever produced her monumental series, *Changing New York*?

In other instances, professional associations between photographers have helped to insure their individual places in photographic history. Thus, Frederick H. Evans and Frank Sutcliffe are remembered partly because of their membership in the Linked Ring (a British pictorialist photography club established in 1892) and Margaret Bourke-White and W. Eugene Smith are celebrated under the rubric of photographers who worked for *Life* magazine.

Furthermore, in the art world of photography in which a work cannot be judged with the statistical integrity of a balance sheet or a box score and where the recognition of artistic excellence remains a matter of opinion, networking between artists, publishers, dealers, collectors, editors, curators, and critics can play a significant role in determining an artist's reputation. Although we trust that the best artwork is acclaimed on the basis of its inherent quality, we also can admit that the process is facilitated if you have a relative who is already a famous artist or a friend who owns a gallery.

These observations are not meant to suggest that some ignoble cronyism has sullied what would have been the true course of photography. Rather, they assert that there is a latent sociology to art history, in how it is created, and in how it is recorded.

Cameraderie illustrates a chronology of acquaintances and affiliations which occurred throughout the history of photography. These relationships are revealed as the rudimentary infrastructure upon which more extended patterns of photographic activity developed. Beginning and ending with a William F. H. Talbot photograph from 1843, *Cameraderie* presents a circuit of sixty-four images by sixty-four artists to demonstrate the connections between photographers from different countries and different eras, as well as the continuity of and diversity of the New Orleans Museum of Art's comprehensive collection.

Steven Maklansky
CURATOR OF PHOTOGRAPHS

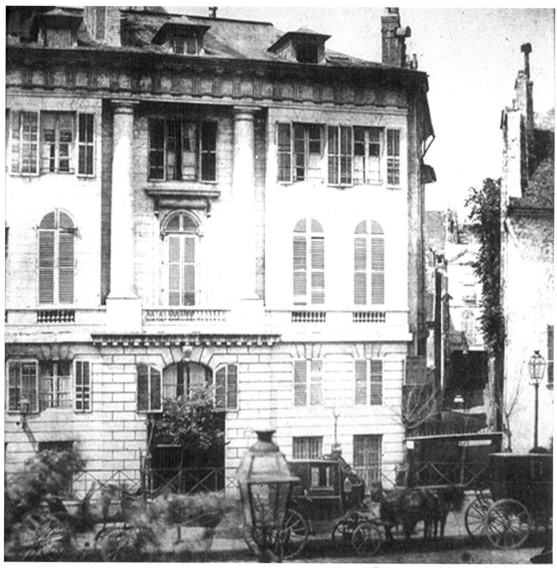

William Henry Fox Talbot. English, 1800-1877
View of the Paris Boulevards from the 1st Floor of the Hotel de Louvois, Rue de la Paix, 1843
Salted paper print, 6$\frac{1}{2}$" x 6$\frac{3}{4}$"
Museum Purchase, 77.66

William Henry Fox Talbot invented photographs on paper in 1839. His patents prevented others in England from profiting from his discovery. However, one of Talbot's assistants named Tanner stole away to France where he shared the technology with L. D. Blanquart-Evrard. ➡

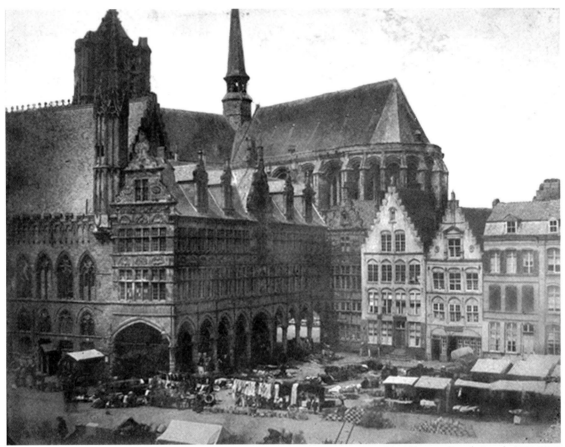

Louis-Désiré Blanquart-Evrard. French, 1802-1872
Ypres, Belgium from *Album photographique de l'Artiste et de l'Amateur, Lille,* 1851
Salted paper print, 6¼" x 8¼"
Museum Purchase, Women's Volunteer Committee Funds, 73.114

Blanquart-Evrard improved upon Talbot's methods, developing techniques to facilitate the rapid reproduction of photographic prints. In 1851 Blanquart-Evrard opened a photographic printing house which published the work of many early French and British photographers, including Charles Marville. ➡

Charles Marville. France, 1816-1879
Chateau de St. Germain-en-Laye, circa 1876
Albumen print, 14$\frac{1}{8}$" x 10$\frac{1}{2}$"
Museum Purchase, 81.360

harles Marville is best known for his images of old Paris. However, he also produced landscape photographs while cavorting with French painters of the Barbizon school such as Corot and Diaz. Another photographer who participated in these outings was Gustave Le Gray. ➡

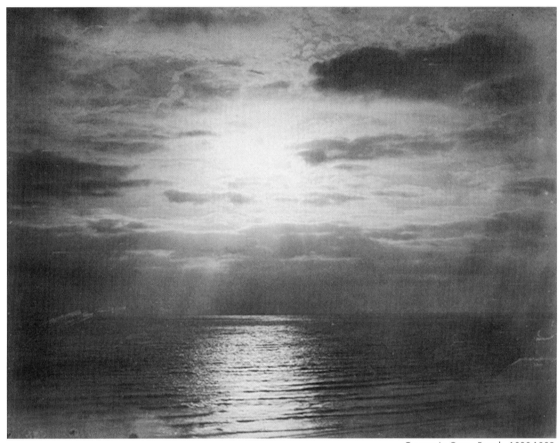

Gustave Le Gray. French, 1820-1882
Mediterranean Sea at Site, 1857
Albumen Print, 11³/₄" x 15¹/₂"
Museum Purchase, The Clarence John Laughlin Photographic Society Fund, 88.210

Gustave Le Gray is remembered for many photographic accomplishments, including his pioneering use of multiple negatives to create a single image. In 1851, he was one of the photographers named by the Historic Monuments Commission of the French Heliography Society to document France's architectural treasures. He was joined in this endeavor by Edouard-Denis Baldus. ➡

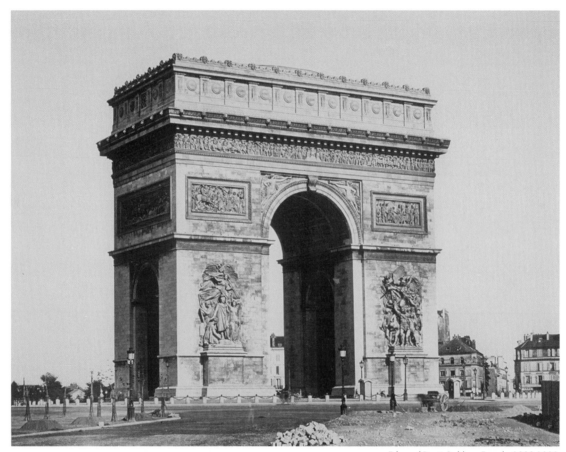

Edouard-Denis Baldus. French, 1820-1880
Arc de Triomph, 1852
Albumen print, 9" x 12½"
Museum Purchase, George S. Frierson, Jr. Fund, 89.51

douard-Denis Baldus received many government commissions to photograph the French countryside, monuments, and railroads. In 1857 he joined the French Society of Photography which was begun in 1854 with the aim of popularizing the medium. One of the society's founding members was Charles Nègre. ➡

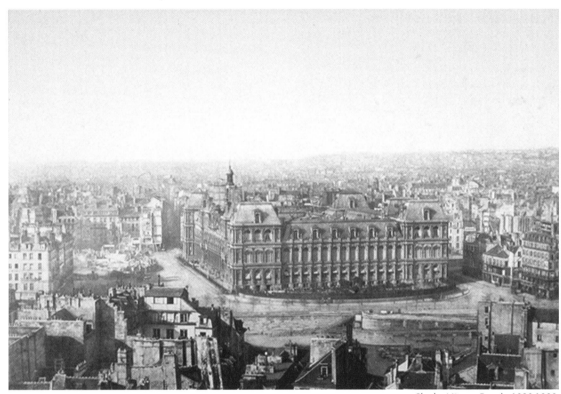

Charles Nègre. French, 1820-1880
Hotel de Ville from Notre Dame Cathedral, circa 1852
Salted paper print, 9″ x 12^1/$_2$″
Museum Purchase, George S. Frierson, Jr. Fund, 89.51

Charles Nègre was one of the most prominent photographers of his era. He brought a painter's sense of composition to his work. He had studied painting in the studio of Paul Delaroche along with other young artists who would soon become famous photographers, including Roger Fenton. ➡

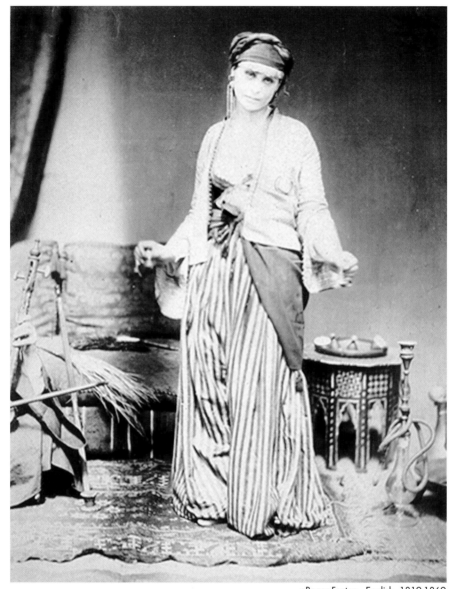

aRoger Fenton. English, 1819-1869
Arab Costume, circa 1862
Albumen print, 8¼" x 6½"
Museum Purchase, Zemurray Foundation Fund, 76.277

Roger Fenton served as an enthusiastic intermediary between British and French photographers. He also traveled throughout Russia, and is perhaps best known for his photographs of the Crimean War. On September 1, 1855, Fenton's tour of photographic duty ended when he was replaced by James Robertson. ➡

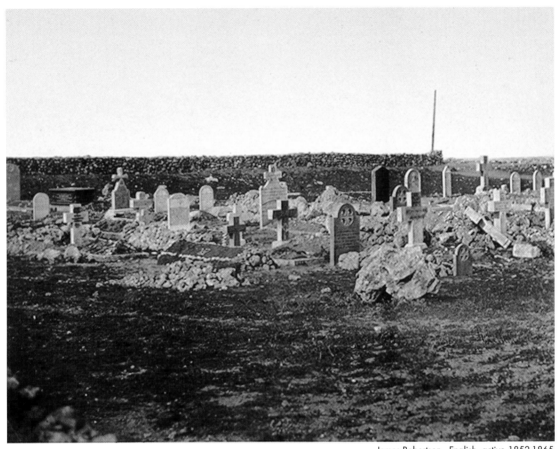

James Robertson. English, active 1852-1865
The Cemetery at Cathcarte, circa 1860
Salted paper print, 8⁷/₈″ x 11³/₄″
Museum Purchase, 81.346

James Robertson was one of the world's first great war photographers. Besides photographing the Crimean War, Robertson also documented the Indian Mutiny of 1857, and the Opium War of 1860. From 1852 to 1865 his partner was Felice A. Beato. ➡

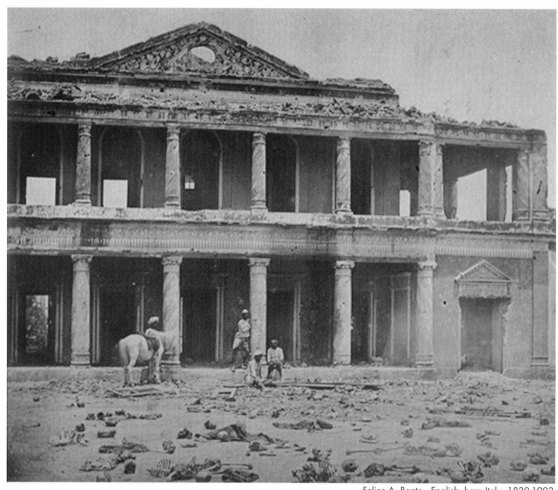

Felice A. Beato. English, born Italy, 1830-1903
Interior of the Secundra Gagh, Lucknow, after the Indian Mutiny of 1857-58
Albumen print, 10" x 11³/₄"
Museum Purchase, 77.67

elice A. Beato continued to work as an expeditionary photographer after his partnership with James Robertson was dissolved in 1865. His journeys would take him throughout Asia including China and Japan. During his second trip to China in 1870, Beato met another adventurous photographer, John Thomson. ➡

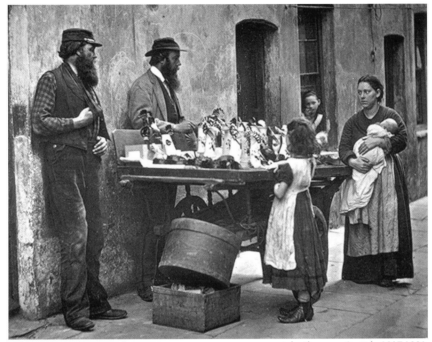

John Thomson. Scottish, 1837-1921
Dealer in Fancy Wear from *Street Life in London, London*, 1877-1878
Woodburytype, $3^{1}/_{2}$" x $4^{1}/_{2}$"
Museum Purchase, Women's Volunteer Committee Fund, 73.234

ohn Thomson returned to England in 1872. Now turning his attention closer to home, he photographed the street life of London. In 1881 Thomson became official photographer to Queen Victoria, who had commissioned and collected works from many photographers, including Oscar Rejlander. ➡

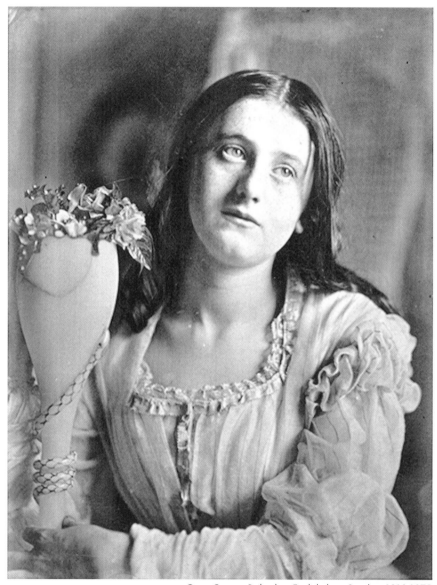

Oscar Gustave Rejlander. English, born Sweden, 1813-1875
Miss Constable, 1866
Albumen print, 8" x 6½"
Museum Purchase, 79.62

scar Rejlander was a leader in the struggle to have photography recognized as an art form. His achievements gained him a place amidst Great Britian's leading artists and scientists. Rejlander photographed many of these great men and women including Alfred Tennyson, Charles Darwin, and Charles Dodgson. ➡

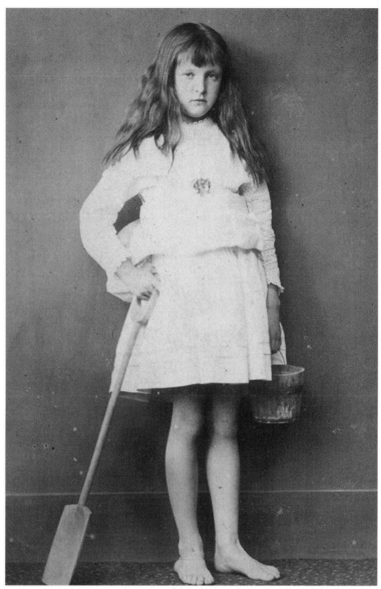

Lewis Carroll (Charles Lutwidge Dodgson). English, 1832-1898
Xie Kitchin, circa 1868
Albumen print, 6" x 4"
Museum Purchase, 84.66.1

harles Dodgson is better known by his pen name, Lewis Carroll. Besides authoring *Alice's Adventure in Wonderland*, Dodgson was also a noted mathematician and a productive photographic hobbyist. In 1858 he photographed a Victorian aristocrat who would soon begin her own photographic career, Julia Margaret Cameron. ➡

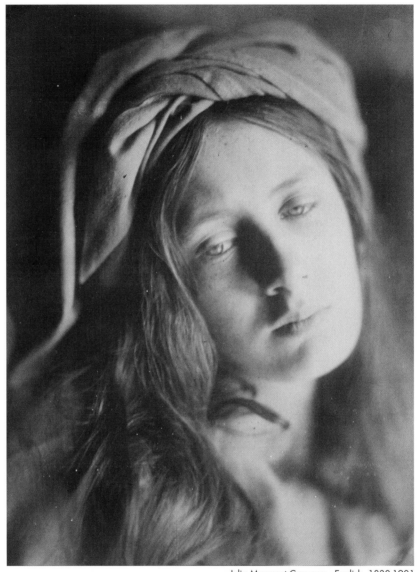

Julia Margaret Cameron. English, 1830-1901
Study of the Beatrice Cenci from May Princep, 1866
Albumen print, 13" x 10"
Museum Purchase, Women's Volunteer Committee Fund, 73.225

Julia Margaret Cameron did not begin photographing until she was forty-eight years old. Her soft focus style and frame-filling portraits were controversial in their day. They were criticized for their lack of precision by one of the most famous photographers of the period, Henry P. Robinson. ➡

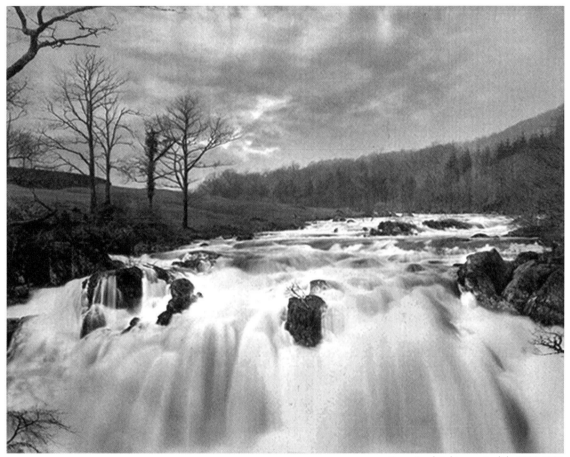

Henry Peach Robinson. English, 1830-1901
River Rapids, circa 1885
Platinum print, 7¹/₄″ x 9¹/₄″
Museum Purchase, 79.207

enry P. Robinson was a leading practitioner and author on "high art" photography during the second half of the nineteenth century. In 1892 he was one of the founders of the Linked Ring Society, an organization which promoted photography as a separate and distinct form of art. The Linked Ring included many eminent artists, including Frederick Hollyer. ➡

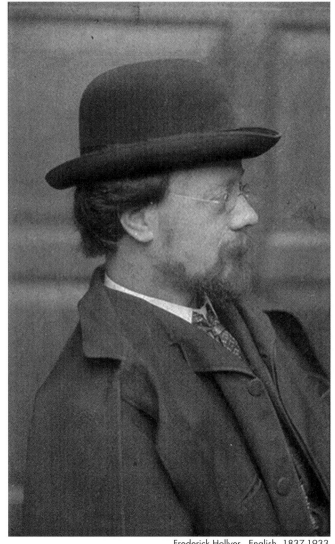

Frederick Hollyer. English, 1837-1933
Frederick H. Evans, 1880-1900
Platinum print, 5³/₄" x 3¹/₂"
Museum Purchase, Zemurray Foundation Fund, 75.165

Frederick Hollyer had been an active photographer for thirty years before his initiation into the Linked Ring Society in 1892. During an early stage in his career, he sold photographic reproductions of famous paintings. However, Hollyer is best known for his penetrating portraits of other artists, such as a fellow member of the Linked Ring, Frederick Henry Evans.

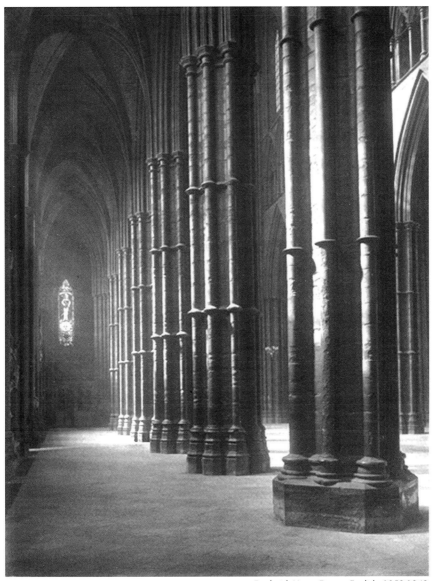

Frederick Henry Evans. English, 1853-1943
South Nave Eisle, to West and Across Nave (Westminister Abbey), 1911
Platinum print, $9^1/_2$" x $7^1/_4$"
Museum Purchase, Women's Volunteer Committee and Dr. Ralph Fabacher Funds, 73.121

Frederick Henry Evans ran a bookstore in London for many years before closing shop and devoting himself entirely to photography in 1898. Evans' straight and naturalistic approach was a departure from the manipulated and pictorial style that was popular at that time. In 1903 a friendship blossomed between Evans and a young American photographer named Alvin Langdon Coburn. ➡

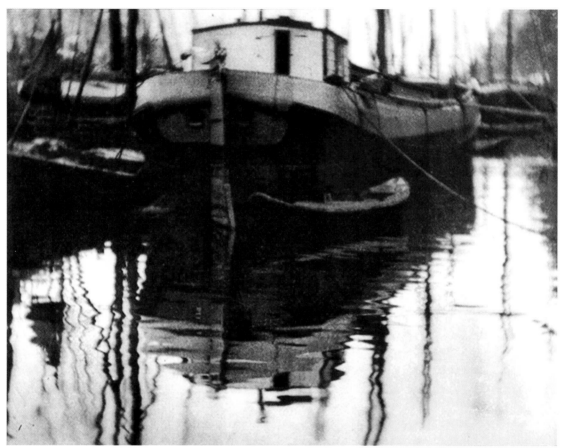

Alvin Langdon Coburn. American, 1882-1966
Canal in Rotterdam, 1908
Photogravure, 11⁷/₈" x 15³/₈"
Museum Purchase, Women's Volunteer Committee Fund, 75.2

lvin Langdon Coburn was something of a photographic prodigy.
By the age of eighteen his work was being seen in important
international exhibitions. In 1903 he worked in the studio of the
most accomplished woman photographer of the time, Gertrude Käsebier. ➡

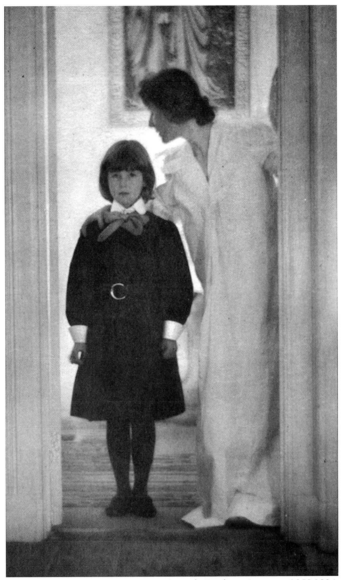

Gertrude Käsebier. American, 1852-1934
Blessed art thou among Women, 1903
Photogravure, 9$\frac{1}{2}$" x 5$\frac{1}{2}$"
Museum Purchase, Women's Volunteer Committee Fund, 73.164

Gertrude Käsebier established her photography studio in New York in 1897. In 1900 she became the first woman photographer elected to the Linked Ring Society. Two years later she helped create The Photo-Secession, an American organization that would promote photography as an art form, with a friend and fellow photographer, Alfred Stieglitz. ➡

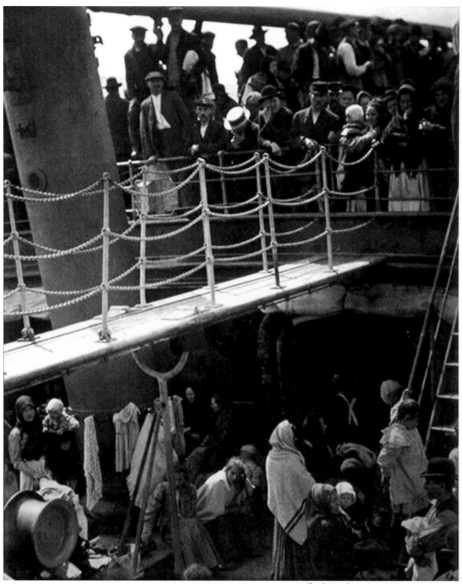

Alfred Stieglitz. American, 1864-1946
The Steerage, 1907
Photogravure on Japan tissue, 12⁷/₈″ x 10¹/₈″
Museum Purchase, Women's Volunteer Committee Fund, 74.37

 lfred Stieglitz was one of the most influential figures in the history of photography. After studying in Europe he returned to New York where he would organize the *Photo-Secession* group, run numerous galleries, and edit various publications about photography. One such journal was *Camera Work*, which published the work of the members of the *Photo-Secession*, including Karl Struss. ➡

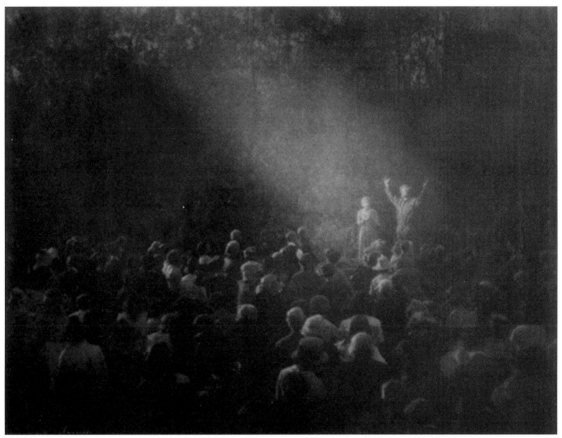

Karl Struss. American, 1886-1981
The Faith Healer, 1921
Platinum print, 10¹/₄" x 13¹/₄"
Museum Purchase, 77.18

arl Struss adapted his skills as a photographer as the basis for his career as a cinematographer. In 1928 he won an Academy Award for his work on the film *Sunrise*, and he was the cinematographer for many later, memorable films including *The Great Dictator* (1940) and *The Fly* (1958). Struss began studying photography in 1908 as a student of another famous photographer, Clarence H. White. ➡

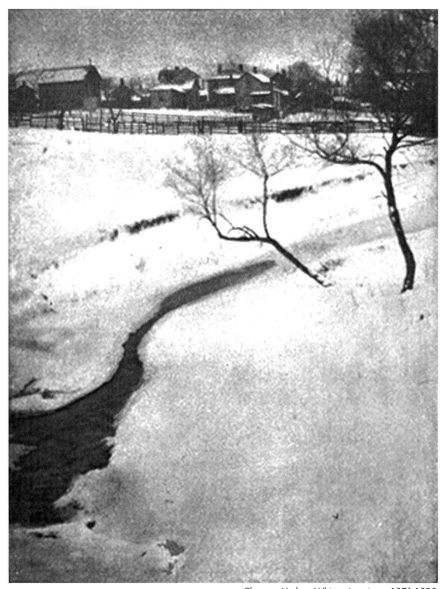

Clarence Hudson White. American, 1871-1925
Winter Landscape, 1903
Halftone from platinum print, 7" x 5 1/2"
Museum Purchase, Women's Volunteer Committee Fund, 73.229

larence Hudson White was an acclaimed pictorialist photographer and an influential teacher. He was a professor first at Columbia University and then at his own school of photography. Many of White's students went on to successful careers in photography, including Paul Outerbridge. ➡

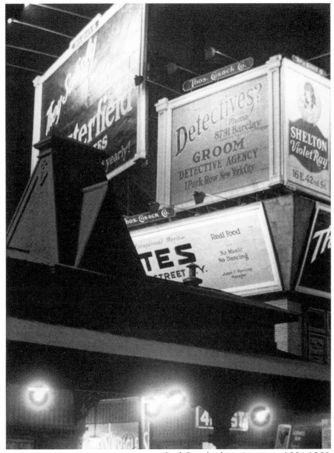

Paul Outerbridge. American, 1896-1958
42nd Street El, 1923
Platinum print, 4¹/₂″ x 3¹/₂″
Museum Purchase, 74.290

Paul Outerbridge worked as a free-lance advertising photographer for *Vogue, Vanity Fair*, and *Harper's Bazaar* magazines. In this capacity he interacted with other prominent artists such as Edward Steichen, Man Ray and Berenice Abbott. Outerbridge attended the C. H. White School of Photography from 1921 to 1922, as did Ralph Steiner. ➡

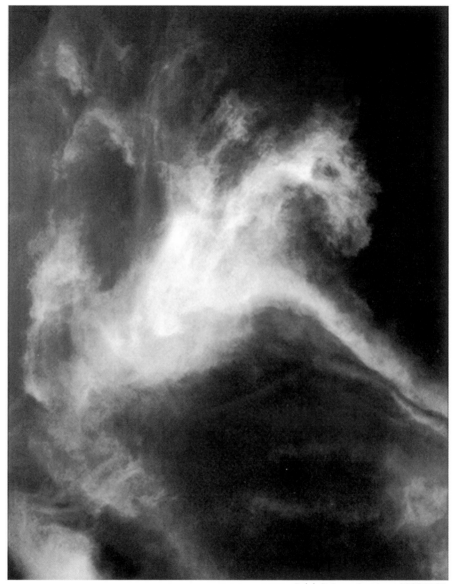

Ralph Steiner. American, 1899-1986
Cloud #42, 1983
Gelatin silver print, $9^{5}/_{8}$" x $7^{5}/_{8}$"
Gift of Dorothy and Eugene Prakapas, 90.125.12

Ralph Steiner studied under Clarence White, made films with Paul Strand, and as an editor of the *PM* illustrated newspaper, introduced Americans to the photographs of Lisette Model. Steiner spent many summers at a vacation home in Maine, where he executed his cloud photographs. As a successful filmmaker and photographer, Steiner once gave advice to a young photographer with similar aspirations, Henri Cartier-Bresson. ➡

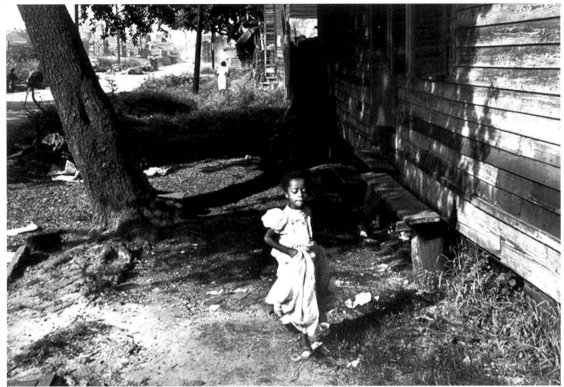

Henri Cartier-Bresson. French, born 1908
Louisiana, 1947
Gelatin silver print, circa 1975, 9½" x 14¼"
Museum Purchase, 80.129

enri Cartier-Bresson related that his photographs captured "decisive moments." In 1947 he assisted in the creation of the Magnum Photo Agency which continues today to assign photographers to cover important people, places, and events. Cartier-Bresson's own career as a photojournalist began when his images appeared in the French magazine, *Vu*, which featured the work of many prominent photographers, including Maurice Tabard. ➡

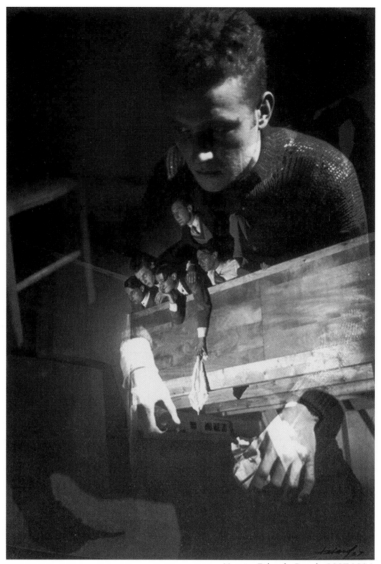

Maurice Tabard. French, 1897-1984
Actors, Montage, 1927
Gelatin silver print, 9" x 6"
Museum Purchase, 79.243

aurice Tabard was born in France but received much of his photographic education in the United States. Returning to Paris in 1928, his work was featured in many fashion and news magazines such as *Vu, L'Art Vivant,* and *Photographie.* Tabard interacted with many Parisian artists and photographers, including André Kertész. ➡

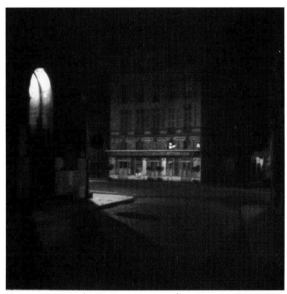

André Kertész. American, born Hungary, 1894-1985
Théâtre Odéon, Paris, 1926
Gelatin silver print, 3″ x 3″
Museum Purchase, Women's Volunteer Committee Fund, 73.170

ndré Kertész came to Paris from Hungary in 1925. Kertész was one of the first photographers to exploit the maneuverability of the 35mm camera. Initially he printed his photographs on postcard stock, which were enjoyed by only a small group of friends and collectors. However, it wasn't long before he was competing for commercial photographic assignments with other Parisian photographers whom Kertész knew well, like Man Ray. →

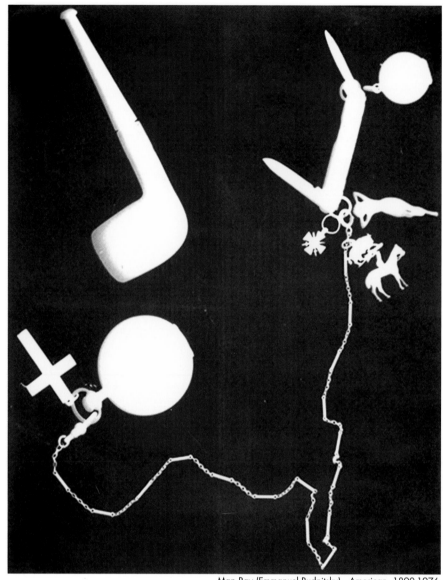

Man Ray (Emmanuel Rudnitsky). American, 1890-1976
Caresse Crosby's Things, 1927
Rayograph, gelatin silver print, 10³/₄" x 8¹/₂"
Museum Purchase with National Endowment for the Arts Grant, 81.208

an Ray was introduced to trends in modernist art during frequent
visits to Stieglitz' *Gallery 291* in New York. Moving to Paris in
1921 Man Ray made his living as a fashion and portrait
photographer while pursuing more unusual artistic endeavors on the side. He
participated in the cubist, dada, and the surrealist art movements, the latter
which had been launched with a stirring manifesto by André Breton. ➡

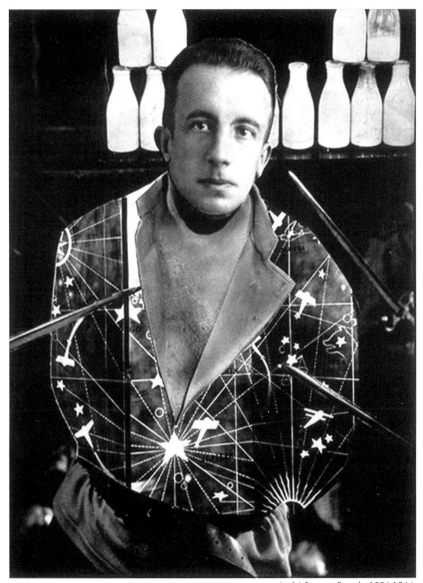

André Breton. French, 1896-1966
La Nourrice des Etoiles: Paul Eluard (The Nurse of the Stars: Paul Eluard), 1935
Gelatin silver print, 11¼" x 8¼"
Museum Purchase, 87.42

ndré Breton was a radical philosopher, writer, and artist whose ideas
had profound effects on the course of twentieth-century art. His Surrealist
Manifesto recognized the unconscious mind as a potent source of artistic
inspiration, and his later writings identified photography's ability to suggest the
enigmatic and allegorical quality of ordinary objects, places or experiences.
Breton found an example of these photographic traits in the work of Eugène Atget. ⟹

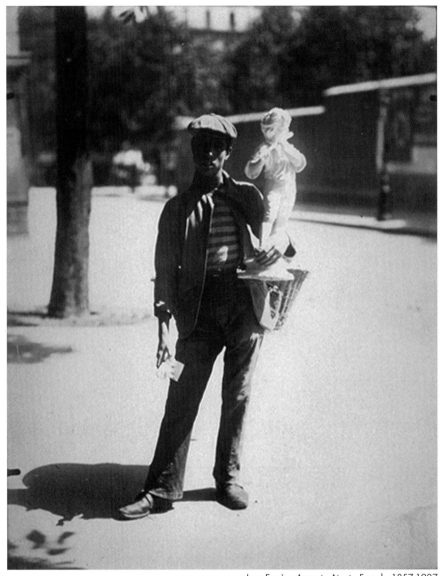

Jean-Eugène-Auguste Atget. French, 1857-1927
Marchand de moulages, avenue de l'Observatior (Seller of plaster casts), circa 1900
Silver-chloride printing-out paper, 9" x 7"
Museum Purchase, Women's Volunteer Committee Fund, 74.69

ugène Atget did not begin his professional career until he was forty-three years old. Seeing himself as more of a documentalist than an artist, Atget produced more than 10,000 images of Paris. Atget's plan to sell these photographs to architects, designers, artists and historical societies was largely unsuccessful, but his work was rescued from obscurity by a young photographer named Berenice Abbott. ➡

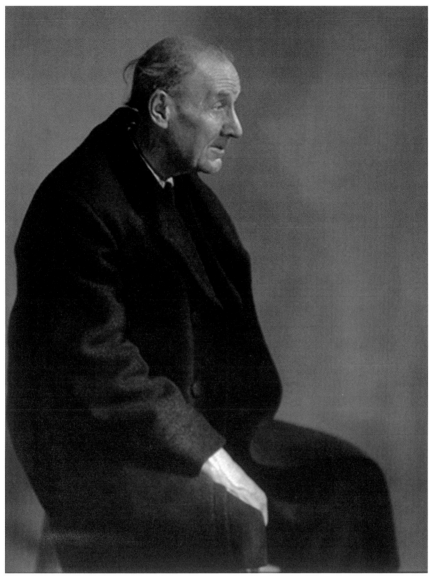

Berenice Abbott. American, 1898-1991
Eugène Atget, Paris, 1927
Gelatin silver print, circa 1970, 14" x 10¹⁄₄"
Museum Purchase with National Endowment for the Arts Grant, 75.58

Berenice Abbott was working in Paris as an assistant to Man Ray when she was introduced to Atget. She was so impressed with Atget's photographs that she cataloged and promoted them, and they also inspired her to make a photographic record of New York, similar to the one Atget had created of Paris. Besides working as a free-lance photographer, Abbott taught photography classes at the New School for Social Research, where one of the students was Richard Avedon. ➡

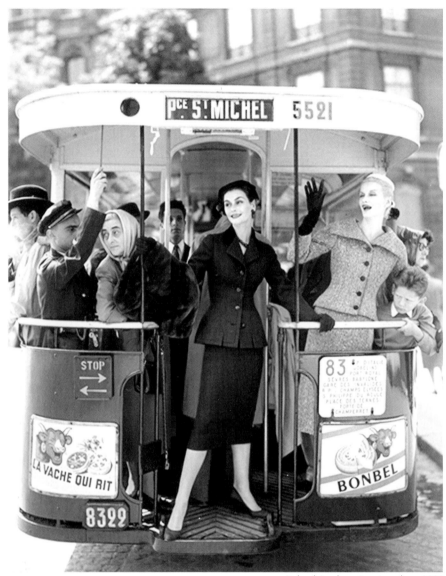

Richard Avedon. American, born 1923
Balenciaga 55 (right) DIOR "Gomeux" 77 (left), 1954
Gelatin silver print, 9⁵/₈" x 7⁵/₈"
Museum Purchase with National Endowment for the Arts Grant and Jeunesse d'Orleans Fund, 78.174

Richard Avedon opened his studio in 1946 and immediately began photographing fashion layouts for major magazines. Besides his fashion work, Avedon is renowned for his large portraits which have a clinical style achieved with strong lighting and a plain white background. During the early part of his career, Avedon attended the photography workshops of Alexey Brodovitch, the art director of *Harper's Bazaar* magazine, along with many other famous photographers such as Lisette Model. ➡

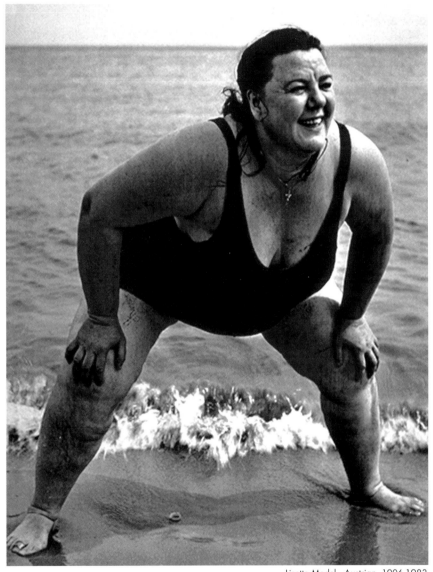

Lisette Model. Austrian, 1906-1983
Coney Island Bather, circa 1940
Gelatin silver print, 1977, 20″ x 16″
Museum Purchase, Mr. & Mrs. Harry J. Blumenthal Fund, 77.384.8

Lisette Model studied music and painting for eighteen years before she applied herself to photography in 1934. Three years later she emigrated to the United States where her satirical style of reportage gained her various magazine assignments. Model's approach to photography strongly influenced her most famous student, Diane Arbus. ➡

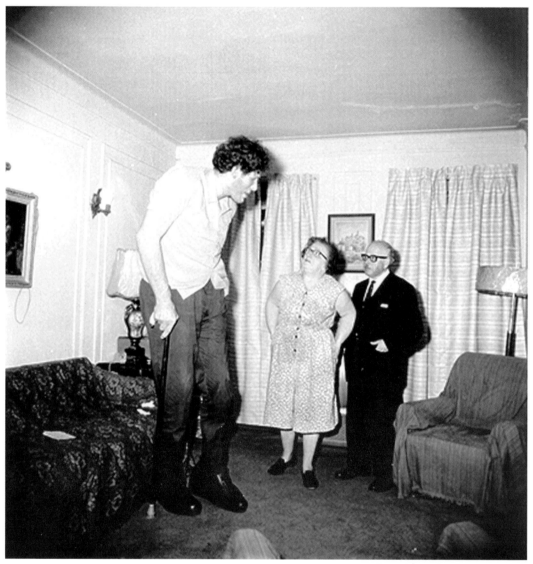

Diane Arbus. American, 1923-1971
A Jewish giant at home with his parents in the Bronx, New York, 1970
Gelatin silver print, by Neil Selkirk, 1973, 14³/₄" x 14³/₄"
Museum Purchase, Ella West Freeman Matching Fund, 73.29.9

Diane Arbus began working as a photographer in the early 1940's. Although her work was published in many magazines, it wasn't until 1967, when Arbus' photographs were included in an exhibition at New York's Museum of Modern Art, that the art world recognized the piercing quality of her portraiture. That exhibition, called *New Documents,* also included the work of another young photographer of the American social landscape, Lee Friedlander.

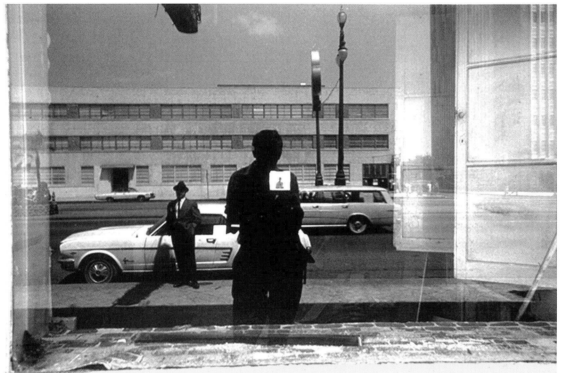

Lee Friedlander. American, born 1934
New Orleans, Louisiana, 1968
Gelatin silver print, 7" x 10³/₄"
Museum Purchase with National Endowment for the Arts Grant, 75.83

ee Friedlander has focused his guileless camera on an eclectic range of subjects including trees, monuments, factory workers, and himself. Working as an inconspicuous witness of people and places, Friedlander creates a subjective photographic account of his experiences. This lonesome style of reportage was also employed by Friedlander's close friend, Garry Winogrand. ➡

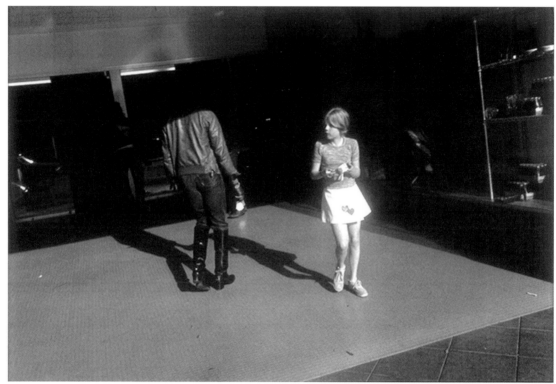

Garry Winogrand. American, 1928-1984
978 Beverly Hills, California, 1978
Gelatin silver print, 9" x 13¼"
Gift of Rudolph Demasi, 81.414.11

Garry Winogrand relied on the facility and maneuverability of the 35mm camera to make blunt but evocative snapshots of his experiences. His photographs seem to demonstrate a sociologist's tendency to take special notice of ordinary gestures and interactions. Undoubtedly this sensitivity was fostered when Winogrand was a photography student at New York's New School for Social Research, where he would later serve as an instructor, along with other master photographers including Philippe Halsman. →

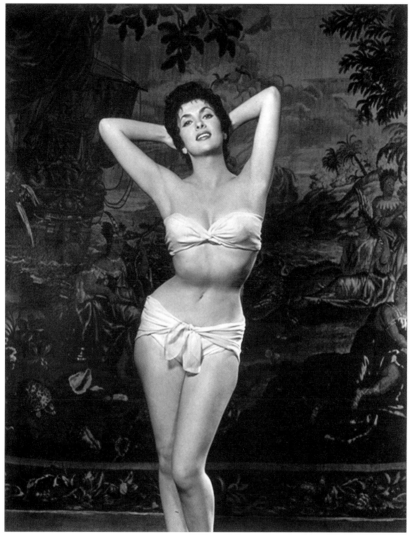

Philippe Halsman. American, born Latvia, 1906-1979
Gina Lollobrigida, 1954
Gelatin silver print, 13³/₄" x 10³/₄"
Gift of Alvin Murstein, 81.333.20

Philippe Halsman was one of many photographers who emigrated to the United States just prior to World War II. Renowned for his incisive portraits, Halsman photographed many of the leading politicians and celebrities of his day. One hundred one of his photographs were used as covers for *Life* magazine, which featured the work of many insightful photographers, such as W. Eugene Smith. ➡

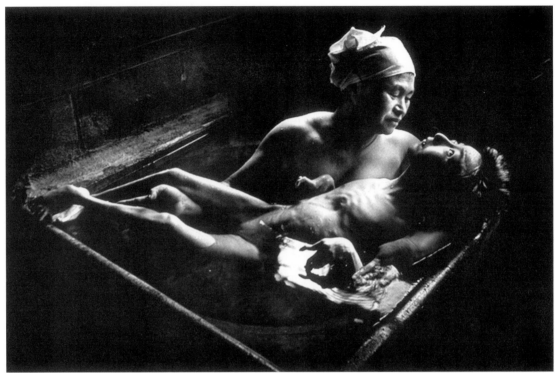

W. Eugene Smith. American, 1918-1978
Tomoko in her Bath, from the *Minimata* essay, 1971
Gelatin silver print, 11½" x 18¼"
Museum Purchase with National Endowment for the Arts Grant, 75.347

W. Eugene Smith was one of the most widely published photojournalists of the twentieth century. This photograph, taken from a twenty-two-image photographic essay, documents the human costs of the mercury poisoning afflicting a small Japanese fishing village. *Life* magazine which published *Minimata* in 1972, pioneered the concept of the photographic essay as a unique format of narrative journalism, well suited to talents of Smith and his fellow staff photographers, including Margaret Bourke-White. ➡

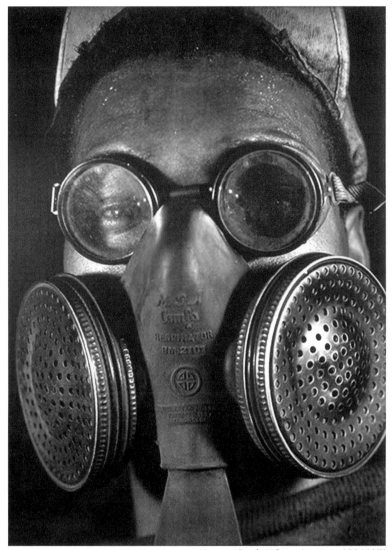

Margaret Bourke-White. American, 1904-1971
Aluminum Co. of America, Louis Klinkscales – a Shake Out Man, 1939
Gelatin silver print, 13½" x 10"
Museum Purchase, 79.38

argaret Bourke-White, like other famous photographers such as Dorothea Lange, Ralph Steiner, and Paul Outerbridge Jr., studied photography with Clarence H. White. Her early work as an industrial photographer brought her to the attention of magazine publisher Henry Luce, who hired her to make photographs first for *Fortune* magazine, and then for *Life*. Bourke-White was one of *Life* magazine's World War II correspondents, as was Carl Mydans. ➡

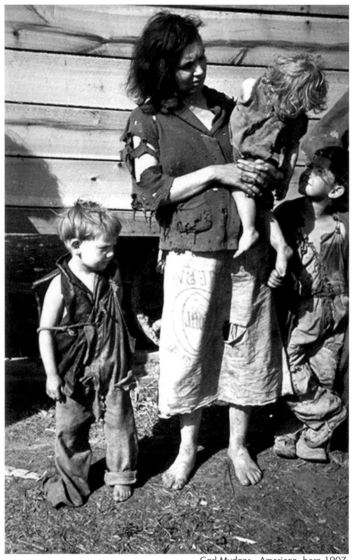

Carl Mydans. American, born 1907
Family Camped off U.S. 70 near Tennessee River, March, 1936
Gelatin silver print, 1976, 9¹/₂" x 6¹/₂"
Museum Purchase, Zemurray Foundation Fund, 76.448

arl Mydans' career as a photojournalist was interrupted for twenty-one months during 1942 to 1943 when he was imprisoned by the Japanese during World War II. He was released in exchange for Japanese prisoners and continued his work making memorable photographs for *Life, Time, Fortune,* and many other publications. Mydans had developed his skills as a sensitive photographic witness while working for the depression-era Farm Security Administration with other dedicated photographers, like John Vachon. →

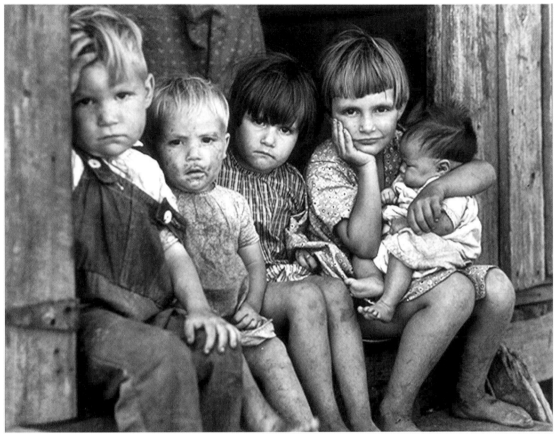

John Vachon. American, 1914-1975
Children of Farmer in the Ozarks, Missouri, March, 1940
Gelatin silver print, circa 1975, 10" x 13¼"
Museum Purchase, Zemurray Foundation Fund, 76.432

J ohn Vachon originally worked as an assistant messenger for the Farm Security Administration. There he was impressed by the photographs which F.S.A. photographers such as Arthur Rothstein and Russell Lee were submitting that documented the plight of poor and unemployed Americans during the Depression. Soon Vachon was taking his first lessons in photography from another F.S.A. photographer, Ben Shahn. ➡

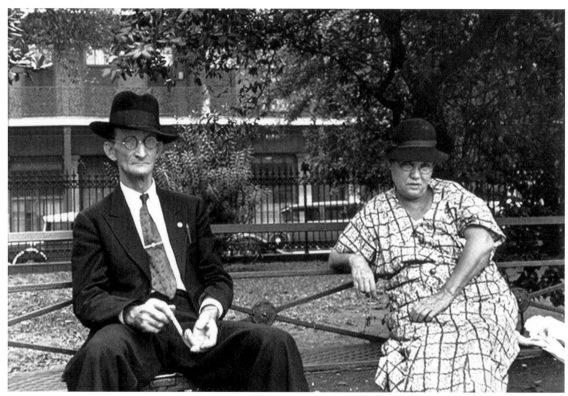

Ben Shahn. American, born Lithuania, 1898-1969
Jackson Square, New Orleans, 1935
Gelatin silver print, circa 1978, 6$^1/_4$" x 9$^1/_2$"
Museum Purchase, 78.86

Ben Shahn shot more than 6,000 photographs for the F.S.A. from 1935 to 1938. Before and after this period of intense photographic achievement, Shahn worked as an accomplished painter, printmaker and graphic designer. From 1929 to 1930 he shared a studio in New York's Greenwich Village with a young photographer named Walker Evans. ➡

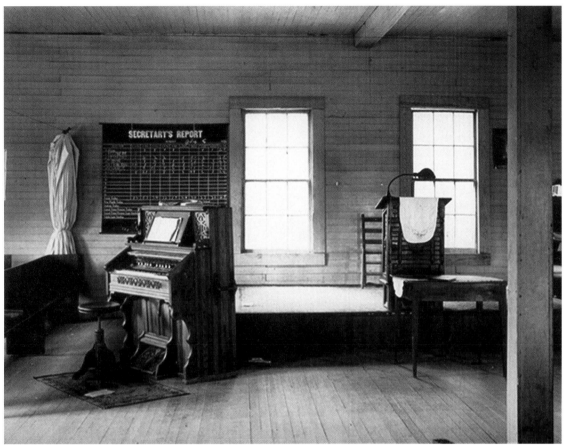

Walker Evans. American, 1903-1975
Church Interior, Alabama, August, 1936
Gelatin silver print, 7⅛″ x 9″
Museum Purchase with National Endowment for the Arts Grant, 75.19

Walker Evans was the first photographer to have a solo exhibition at New York's Museum of Art, in 1933. His calm and direct photographs have influenced generations of artists who share Evans' appreciation for the way that looking through a viewfinder can bring order to experience. Evans applied his straightforward approach to all his photographic endeavors, including a short stint working for the Farm Security Administration with other concerned photographers such as Dorothea Lange.➡

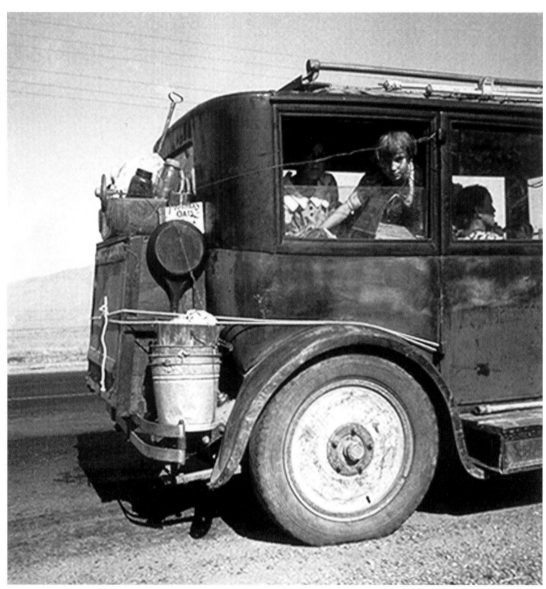

Dorothea Lange. American, 1895-1965
Drought Refugees from Abilene, TX, August, 1936
Gelatin silver print, circa 1979, 10¹/₂" x 10¹/₂"
Museum Purchase, with grant for State Travelling Exhibitions Programs, 79.324

orothea Lange's photographs of migrant workers, made for the
California Rural Rehabilitation Administration, were used to help
justify the creation of the photographic unit of the Federal Farm
Security Administration which she joined in 1935. Earlier Lange had
studied photography with Clarence White and worked as an assistant for
Arnold Genthe before opening her own portrait studio in San Francisco.
In 1952, Lange worked with a group of photographers and curators to
create *Aperture* magazine, whose first editor and production manager
was Minor White. ➡

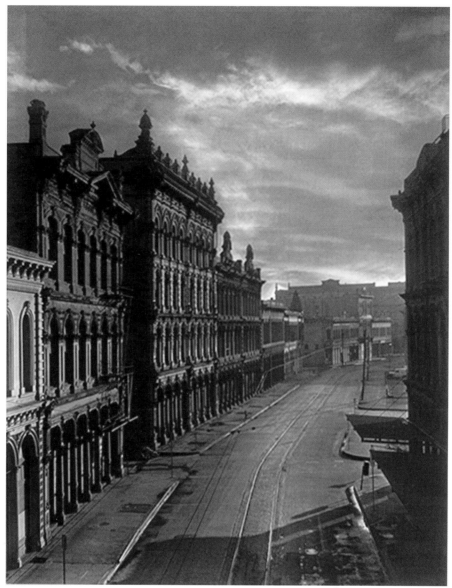

Minor White. American, 1908-1976
Front Street - Portland, Oregon, 1939
Gelatin silver print, 13½" x 10½"
Museum Purchase with National Endowment for the Arts Grant, 75.287

inor White took a spiritual approach to making photographs and a more methodical approach to looking at them. His career as a photographic educator lasted thirty-eight years, beginning at the YMCA in Portland, Oregon, and culminating at the Massachusetts Institute of Technology. In 1945 to 1946, White came to New York to learn about photography and museum methods from Beaumont Newhall, the curator of photography at the Museum of Modern Art, who introduced White to his circle of friends which included Paul Strand. ➡

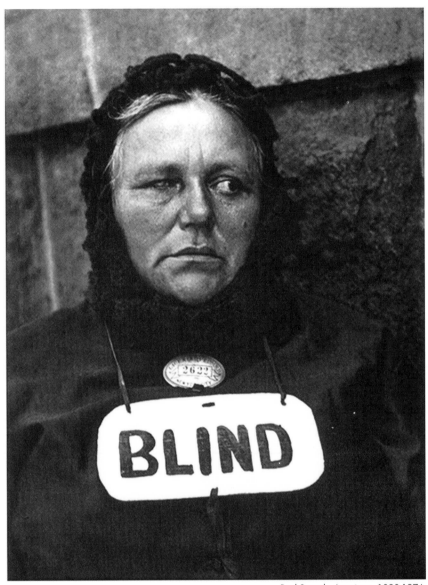

Paul Strand. American, 1890-1976
Blind Woman, New York, 1916
Photogravure, 8³/₄" x 6¹/₂"
Museum Purchase, Women's Volunteer Committee Fund, 73.184

Paul Strand studied photography in high school with the famous
photographer, Lewis Hine. He went on to a seventy-year career
as a photographer and filmmaker. Strand produced films with a
variety of noted collaborators including Ralph Steiner, Charles Sheeler,
and Morris Engel. ➡

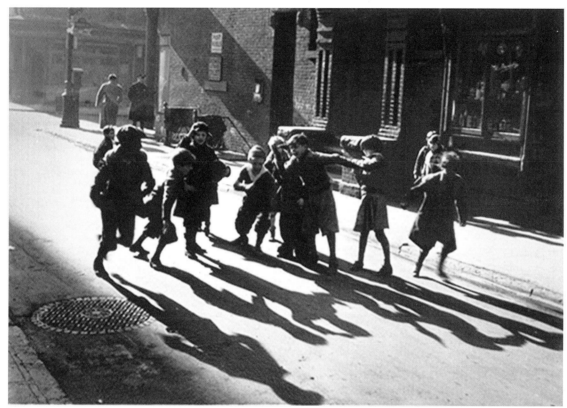

Morris Engel. American, born 1918
The Race, East Side, New York City, 1937
Gelatin silver print, circa 1980, 4¹⁄₄" x 6¹⁄₄"
Museum Purchase, 85.147.1

Morris Engel has made photographs documenting the street life of New York City for sixty years. His film, *The Little Fugitive*, which chronicled the adventures of a young boy at Coney Island beach and amusement park, received an Academy Award nomination in 1953. Engel's appreciation of the photographic potential of the streets was advanced through his membership in the Photo League, an organization of politically conscious filmmakers and photographers, like Max Yavno. ➡

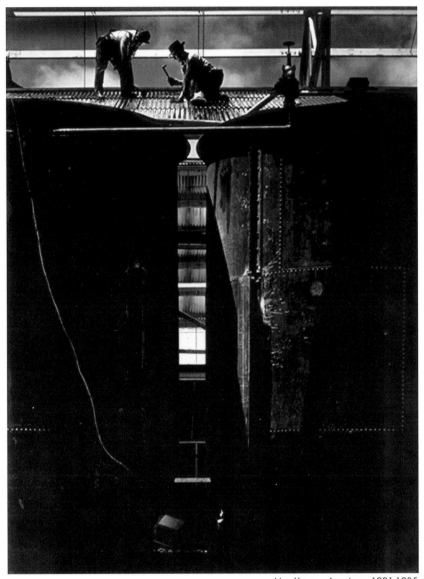

Max Yavno. American, 1921-1985
Untitled (Men on Tanks), circa 1947
Gelatin silver print, circa 1976, 13¼" x 10½"
Museum Purchase, Mr. and Mrs. P. Roussel Norman Fund, 76.65

ax Yavno was president of the Photo League from 1938 to 1939. The Photo League, which was founded in 1928 to create photographs and films for pro-labor magazines, evolved into an organization with more general photographic interests. Before it disbanded in 1951, the Photo League promoted the work of photographers as diverse as Eugène Atget, Lewis Hine, and Max Yavno's roommate, Aaron Siskind. ➡

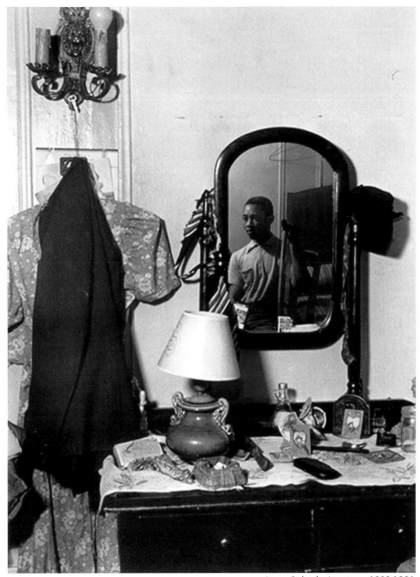

Aaron Siskind. American, 1903-1991
Untitled from *The Most Crowed Block in the World* series, 1940-1941
Gelatin silver print, circa 1980, 12" x 8³/₄"
Museum Purchase, 82.67

aron Siskind directed the Harlem Document group of the Photo League between 1936 and 1939. Siskind abandoned the Photo League as his photographic interests moved away from social documentation towards more abstract subject matter. Siskind taught photography at both the Chicago and Rhode Island Institute of Design and was a founding member of the Society for Photographic Education along with other influential educators like Henry Holmes Smith. ➡

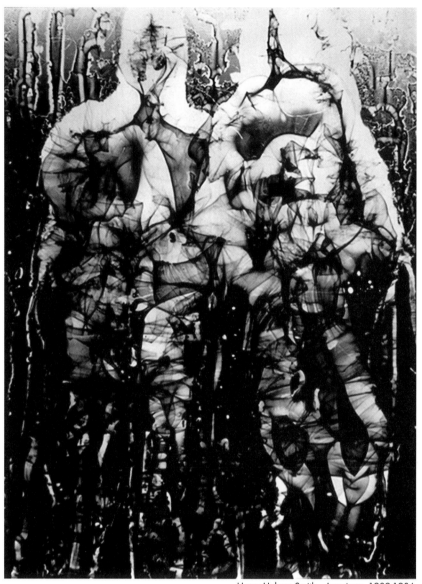

Henry Holmes Smith. American, 1909-1986
Husband and Wife, 1960
Gelatin silver print, 12" x 9"
Gift in memory of Mrs. Mary Patterson Durham Collier, 73.17.4

enry Holmes Smith's lectures and photographic experiments impressed scores of students (including photographers Betty Hahn, Jack Welpott, and Jerry Uelsmann) during his thirty-year tenure at Indiana University. Smith also published many articles and books on individual photographers and on photography appreciation. Smith's interest in camera-less photography developed during his years as a student, and then as an instructor at the Chicago Institute of Design, a position which was also held by Gyorgy Kepes. ➡

Gyorgy Kepes. American, born Hungary 1906
Photodrawing, 1974
Gelatin silver print, 9$1/2$" x 7$1/2$"
Gift of the Artist, 73.257

Gyorgy Kepes worked as a photographer and graphic designer in Hungary, Germany and England before coming to the United States in 1937. Kepes was one of a group of European artists who fled the political turmoil of their home continent by accepting faculty positions at the New Bauhaus school of design. This school, which would later become the Chicago Institute of Design, was founded by László Moholy-Nagy. ➡

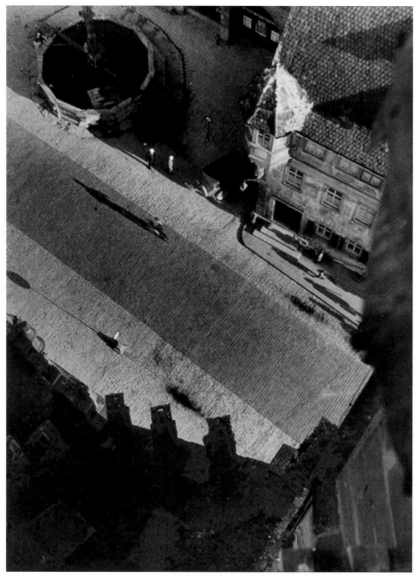

László Moholy-Nagy. American, born Hungary, 1895-1946
Rothenburg, Germany, 1930
Gelatin silver print, 9$\frac{1}{8}$" x 6$\frac{3}{4}$"
Museum Purchase, Zemurray Foundation Fund, 76.289

ászló Moholoy-Nagy applied Futurist and Constructivist ideas to create his "new vision" of photography, seeing it as the dynamic medium for a new generation of technologically astute artists and designers. Moholy-Nagy promoted his theories as a professor at the original Bauhaus School in Germany, and later as the director of the New Bauhaus in Chicago. In these positions he interacted and collaborated with many significant artists, including his wife, Lucia Moholy. ➡

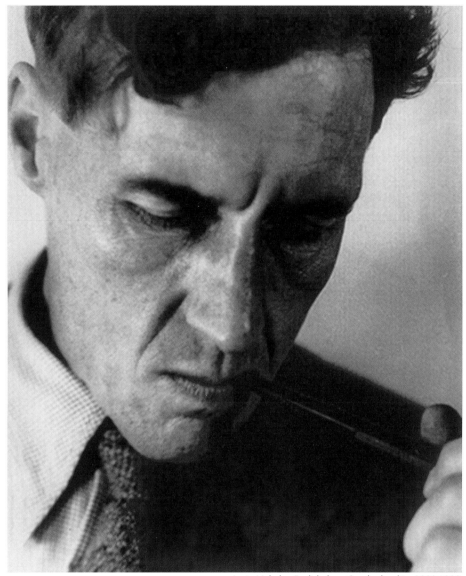

Lucia Moholy. English, born Czechoslavakia, 1899-1989
Portrait of Baron Blackett, 1936
Gelatin silver print, 12" x 10"
Gift of Adam J. and Eileen Boxer, 87.226

Lucia Moholy was married to László Moholy-Nagy from 1921 to 1928. Besides assisting her husband in his photographic experiments, Lucia developed her own strong style of photography. From 1923 to 1928 she worked at the Bauhaus school, doing architectural studies, assisting in the school's publishing activities, and making portraits of her friends and colleagues such as the photographers Florence Henri and Herbert Bayer. ➡

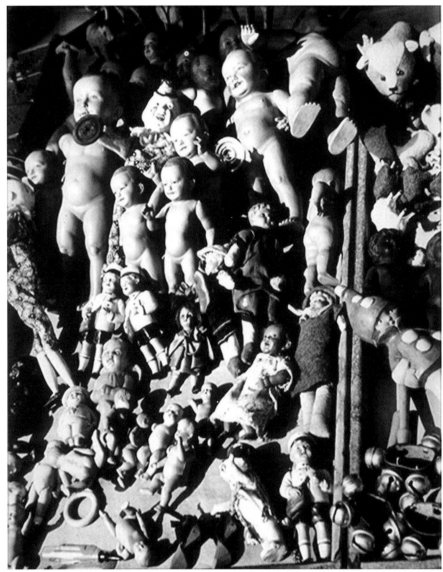

erbert Bayer studied painting with Vassily Kandinsky before experimenting in photography starting in 1924. At the Bauhaus, Bayer taught typography and graphic design which lead to a position as art director for the German edition of *Vogue* magazine. Moving to New York, Bayer assisted in creating the designs of a number of photography exhibitions at New York's Museum of Modern Art which were organized by Edward Steichen.

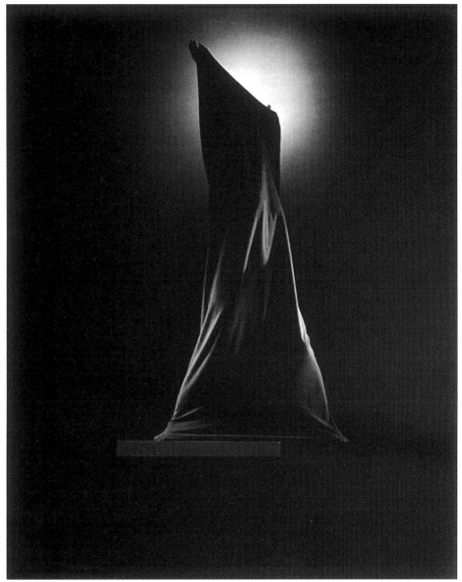

Edward J. Steichen. American, born Luxembourg, 1879-1973
Portrait of Martha Graham, 1931
Gelatin silver print, 9⁷/₈" x 7⁷/₈"
Bequest of Edward Steichen, 82.5.9

dward Steichen was a decisive figure in the promotion of photography as an artistic medium. Steichen's career and imagery evolved as he headed the United States Aerial Photography Corps during World War I, was the chief photographer for *Vogue* magazine from 1923 to 1938, and directed the Museum of Modern Art's photography department from 1947 to 1962, replacing Beaumont Newhall. ⇒

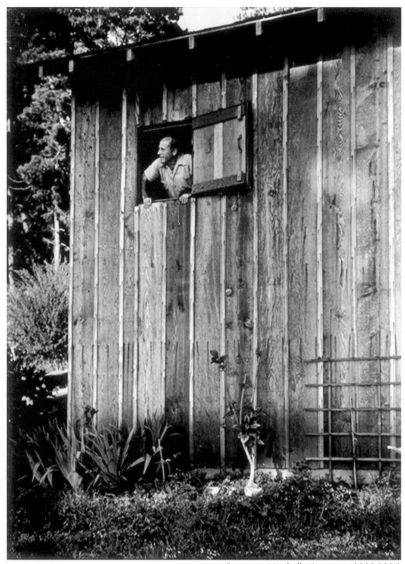

Beaumont Newhall. American, 1908-1995
Edward Weston, 1940
Gelatin silver print, circa 1976, 6½" x 5"
Museum Purchase, Zemurray Foundation Fund, 76.351.13

Beaumont Newhall was one of the most prolific writers on the history of photography and also produced some of his own creative images. His most famous book, *The History of Photography,* was first published in 1937, and continues to be read as a definitive treatment of its subject. Newhall created the department of photography at New York's Museum of Modern Art with the assistance of his friend, the photographer Ansel Adams. ➡

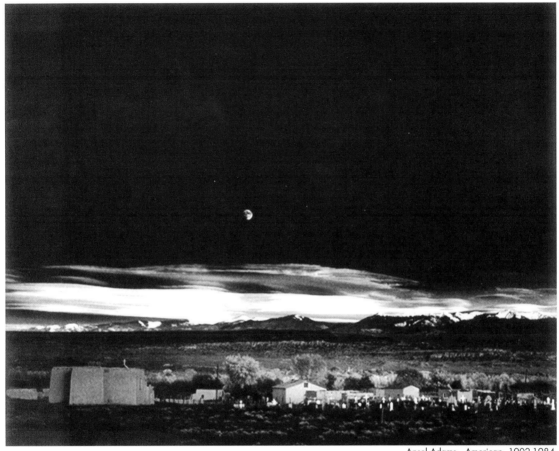

Ansel Adams. American, 1902-1984
Moonrise, Hernandez, New Mexico, 1941
Gelatin silver print, circa 1970 15⅝″ x 19⅜″
Museum Purchase, Women's Volunteer Committee and Dr. Ralph Fabacher Funds, 73.107

nsel Adams created not only hundreds of memorable
photographs, but also many organizations which have nurtured
the study and practice of artistic photography. He participated in
the creation of the Center for Creative Photography at the University of
Arizona in 1970, The Friends of Photography organization of San
Francisco in 1967, the photography department of the Museum of Modern
Art in New York in 1936, and the f/64 group in 1932. Another artist who
was one of the founding members of f/64 was Willard Van Dyke. ➡

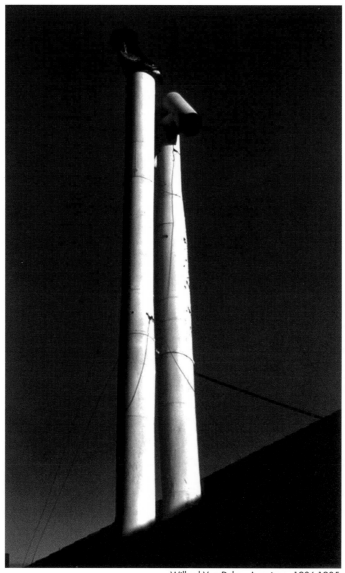

Willard Van Dyke. American, 1906-1985
Ventilators, circa 1930
Gelatin silver print, circa 1975, 9³/₈" x 5⁷/₈"
Museum Purchase, 77.99

Willard Van Dyke, like the other members of f/64 (the name is a reference to a camera-setting which produces sharply focused images), created photographs that were modern and "straight" in defiance of the hazy and pictorialist style of photography that was still popular at the time. In his later career, he produced and directed a number of independant documentary films. Van Dyke first developed his photographic eye as an apprentice to Edward Weston. ➡

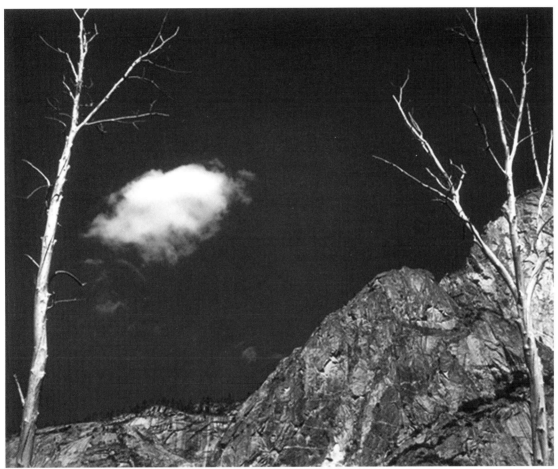

Edward Weston. American, 1886-1958
High Sierra, 1940
Gelatin silver print, 1955, 8" x 10"
Museum Purchase with funds from Jung Enterprises and E. John Bullard, 80.32

dward Weston was a photography purist. Perhaps no other photographer more stridently cultivated an appreciation for the experience of looking through a camera or the unique aesthetic qualities of a photographic image. Weston's ambition to portray the "quintessence" of his various subjects in photographs is still emulated by many contemporary photographers and greatly affected the work of many of his peers, including Imogen Cunningham. ➡

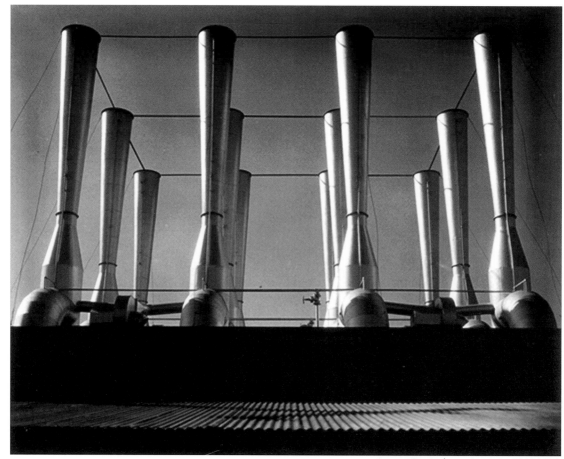

Imogen Cunningham. American, 1883-1976
Fageol Ventilators, Oakland, California, 1934
Gelatin silver print, 7$\frac{1}{2}$" x 9$\frac{1}{2}$"
Gift of Clarence John Laughlin, 83.59.85

mogen Cunningham made photographs for seventy-five years. Although she spent much of her career as a portrait artist, Cunningham is best known for her photographs which emphasize forms as diverse as flowers, nudes and smokestacks. Cunningham learned many of her technical skills as an assistant in the photography studio of Edward S. Curtis. ➡

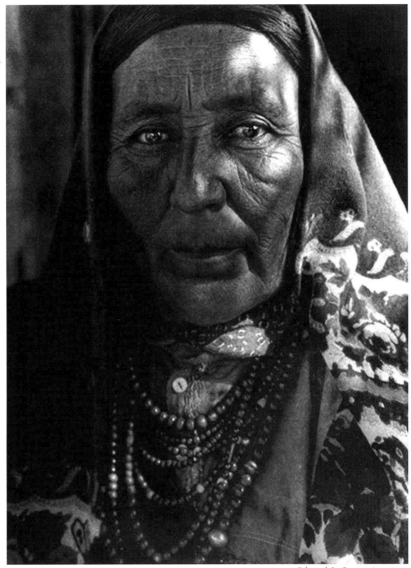

Edward S. Curtis. American
Francisca Chiwiwi, Isleta, 1925
Photogravure, 15½" x 11½"
Museum Purchase, 73.149

dward S. Curtis made more than 40,000 photographs of Native
Americans. Many of these images were published in a massive,
twenty-volume series of books called *The North American Indian*.
While out on the frontier in 1898, Curtis came across the expedition of
C.H. Merriman, who from 1870 to 1878, had lead a U.S. Geological
Survey which was photographed by William Henry Jackson. ➡

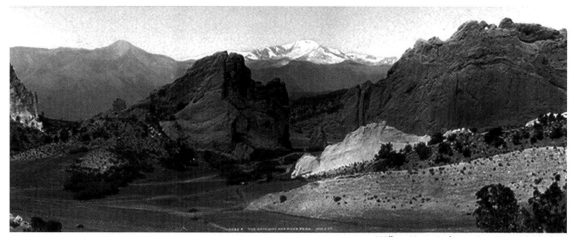

William Henry Jackson. American, 1843-1942
Garden of the Gods, Colorado, 1880
Albumen print with applied color, 7^1/$_2$" x 24^5/$_8$"
Gift of Mrs. P. Roussel Norman, 85.204.1

William Henry Jackson made a number of photographic expeditions throughout the western frontier during the second half of the nineteenth century. Jackson's photographs of the Yellowstone River were instrumental in the successful campaign of 1872 to create the first National Park. Other photographers were simultaneously working on different U.S. government surveys, including Timothy O'Sullivan. ➡

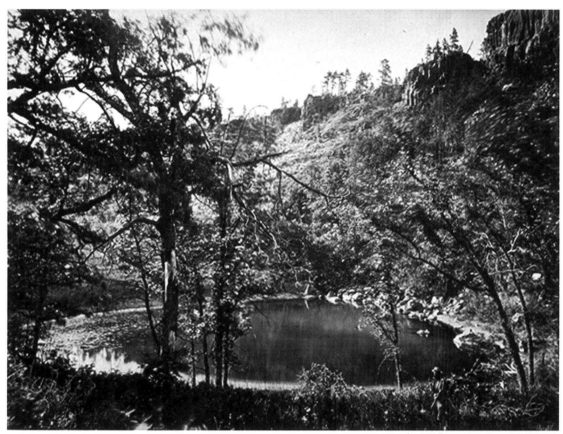

Timothy O'Sullivan, like W. H. Jackson, William Bell and John K. Hillers, was appointed as the official photographer for federal expeditions to explore uncharted western territories. In 1870, O'Sullivan was the photographer for the expedition to search out the best route for the Panama Canal. During the Civil War O'Sullivan worked as a field photographer for Matthew Brady. ➡

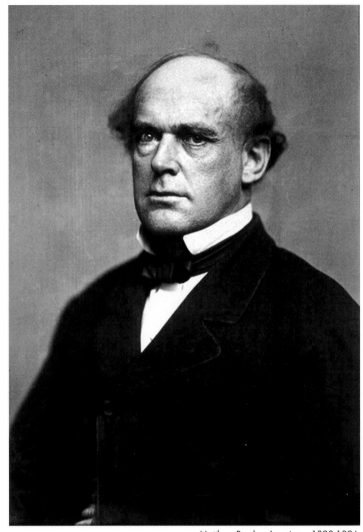

Matthew Brady. American, 1823-1896
Salmon P. Chase, circa 1865
Albumen print, 11³/₄" x 8⁵/₁₆"
Museum Purchase, Women's Volunteer Committee Fund, 73.232

Matthew Brady was the most famous American photographer of the pre-Civil War era. His studios in New York and Washington attracted a huge clientele. Brady hoped to expand his business by selling photographs of the Civil War. However, the expense of making these images proved so costly that at the end of the war Brady was penniless and was forced to turn over the copyright of his Civil War photographs to the man who had loaned him $25,000 worth of photographic equipment, Edward Anthony.

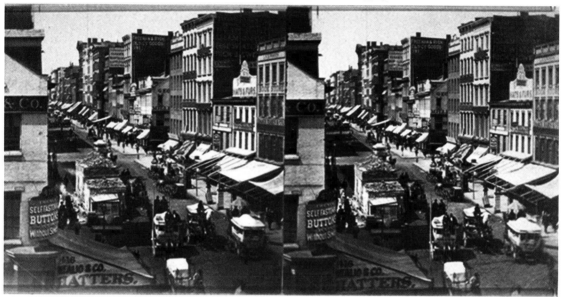

Edward Anthony. American, 1818-1888
and Henry T. Anthony. American, 1813-1883
Broadway, NYC, circa 1875
Albumen print: stereo card, 3$\frac{1}{8}$" x 6$\frac{1}{4}$"
Gift of Mr. & Mrs. Eugene Prakapas, New York, 86.369.328.1

Edward Anthony was an excellent portrait photographer and one of the best photography businessmen of the nineteenth century. From a small studio in 1842, Anthony's business grew to become one of the United State's largest suppliers of photographic chemicals and equipment. In 1846, Anthony had attempted to become the first American to market paper-based photographs, but he was unable to secure the patents for this revolutionary process from the medium's inventor, William Henry Fox Talbot.

Back to page 6. ➡

index